Struggle ■ *Combattre* ■ Kämpfen

Photographs of Magnum Photos • *Photographies de Magnum Photos* • **Fotografien von Magnum Photos**

·TERRAIL·
PHOTO

■ Editor: Jean-Claude Dubost
Desk Editor: Caroline Broué in liaison with Magnum Photos' team
Cover design: Gérard Lo Monaco and Laurence Moinot
Graphic design: Véronique Rossi
Iconographic and artistic coordination at Magnum Photos:
Marie-Christine Biebuyck, Agnès Sire, assisted by Philippe Devernay
English translation: Ann Sautier-Greening
Photoengraving: Litho Service T. Zamboni, Verona

© FINEST SA / ÉDITIONS PIERRE TERRAIL, Paris 1998
The Art Book Subsidiary of BAYARD PRESSE SA
© Magnum Photos, Paris 1998
ISBN 2-87939-164-4
English edition: © 1998
Publication number: 199
Printed in Italy

■ *Direction éditoriale : Jean-Claude Dubost*
Suivi éditorial : Caroline Broué en liaison avec l'équipe de Magnum Photos
Conception et réalisation de couverture : Gérard Lo Monaco et Laurence Moinot
Conception et réalisation graphique : Véronique Rossi
Direction iconographique et artistique à Magnum Photos :
Marie-Christine Biebuyck, Agnès Sire, assistées de Philippe Devernay
Traduction anglaise : Ann Sautier-Greening
Traduction allemande : Inge Hanneforth
Photogravure : Litho Service T. Zamboni, Vérone

© FINEST SA / ÉDITIONS PIERRE TERRAIL, Paris 1998
La filiale Livres d'art de BAYARD PRESSE SA
© Magnum Photos, Paris 1998
ISBN 2-87939-162-8
N° d'éditeur : 199
Dépôt légal : mars 1998
Imprimé en Italie

■ Verlegerische Leitung: Jean-Claude Dubost
Verantwortlich für die Ausgabe: Caroline Broué
in Zusammenarbeit mit dem Magnum Photos Team
Umschlaggestaltung: Gérard Lo Monaco und Laurence Moinot
Buchgestaltung: Véronique Rossi
Bildredaktion und grafische Gestaltung für Magnum Photos:
Marie-Christine Biebuyck, Agnès Sire; Assistent: Philippe Devernay
Deutsche Übersetzung: Inge Hanneforth
Farblithos: Litho Service T. Zamboni, Verona

© FINEST SA / ÉDITIONS PIERRE TERRAIL, Paris 1998
Der Bereich Kunstbücher von BAYARD PRESSE SA
© Magnum Photos, Paris 1998
ISBN 2-87939-163-6
Deutsche Ausgabe: © 1998
Verlegernummer: 199
Printed in Italy

"I walked around all day, my mind occupied, seeking on the streets photographs to be taken directly from life as if in flagrante delicto. I wanted above all to seize in a single image the essence of any scene that cropped up. [...] Photography is the only means of expression which freezes one specific instant", wrote Henri Cartier-Bresson, one of the founding members of the Magnum Photos Agency.

During their assignments to the four corners of the earth, the photographers of this prestigious agency have all wanted to record a certain reality directly seized "from life" and to show the world as they saw and felt it. Their photographs bear witness to the experience of men, to places, times and events which their cameras have managed to capture. The personal imprint they leave on them proves, in the words of John Steinbeck, that "the camera need not be a cold mechanical device. Like the pen, it is as good as the man who uses it. It can be the extension of mind and heart...".

The ambition of the series to which this album belongs is to recall the finest of these "decisive moments", where the eye of the photographer encounters the diversity of the world. Whether it is read like a report or looked at like a film, each album is above all a thematic, historic and aesthetic odyssey bringing together the best pictures from the Magnum photographers.

"Je marchais toute la journée, l'esprit tendu, cherchant dans les rues à prendre sur le vif des photos comme des flagrants délits. J'avais surtout le désir de saisir dans une seule image l'essentiel d'une scène qui surgissait. [...] De tous les moyens d'expression, la photo est le seul qui fixe un instant précis », écrivait Henri Cartier-Bresson, l'un des fondateurs de l'agence Magnum Photos.

Les photographes de cette prestigieuse agence ont tous voulu, au cours de leurs reportages à travers le monde, rendre compte d'une certaine réalité « sur le vif » et montrer le monde tel qu'ils le voyaient et le ressentaient. Leurs photos témoignent de l'expérience d'hommes, de lieux, d'époques et d'événements que leur appareil a su capter. L' empreinte personnelle qu'ils laissent prouve, selon les mots de John Steinbeck, que « l'appareil-photo n'est pas nécessairement une froide mécanique. Comme la plume pour l'écrivain, tout dépend de qui la manie. Il peut être un prolongement de l'esprit et du cœur... »

Restituer les plus beaux de ces « instants décisifs » au fil desquels l'œil du photographe rencontre la diversité du monde, telle est l'ambition de la collection dans laquelle s'inscrit ce livre. À lire comme un récit ou à regarder comme un film, il est avant tout une promenade thématique, historique et esthétique qui rassemble les meilleurs clichés des photographes de Magnum Photos.

"Den ganzen Tag lief ich angespannt herum, denn ich wollte in den Straßen wie auf frischer Tat ertappte, lebensnahe Fotos machen. Vor allem hatte ich den Wunsch, in einem einzigen Bild das Wesentliche eines Geschehnisses festzuhalten [...] Von allen Ausdrucksmitteln ist die Fotografie das einzige, das einen bestimmten Augenblick fixiert", schrieb Henri Cartier-Bresson, einer der Gründer der Fotoagentur Agence Magnum Photos.

Den Fotografen dieser renommierten Agentur liegt viel daran, auf ihren Reportagen in aller Welt von einer gewissen „lebensnahen" Realität Zeugnis abzulegen und die Welt so zu zeigen, wie sie sie sahen und empfanden. Die Fotos sind von ihrem Apparat eingefangene Erfahrungen mit Menschen, Orten, Zeiten und Ereignissen. Der persönliche Eindruck, die sie hinterlassen, beweist, um mit Steinbeck zu sprechen, daß „der Fotoapparat keine kalte Mechanik sein muß. Wie bei der Feder des Schriftstellers hängt alles davon ab, wer sie hält. Und manchmal ist es sogar eine Verlängerung von Geist und Gefühl ..." Die schönsten dieser „entscheidenen Augenblicke" zu zeigen, bei denen das Auge des Fotografen der Vielfältigkeit der Welt begegnet, ist die Absicht dieser Buchreihe. Wie ein Bericht zu lesen oder wie ein Film zu betrachten, ist sie vor allem ein thematischer, historischer und ästhetischer Spaziergang, auf dem die besten Bilder der Fotografen von Magnum Photos zu sehen sind.

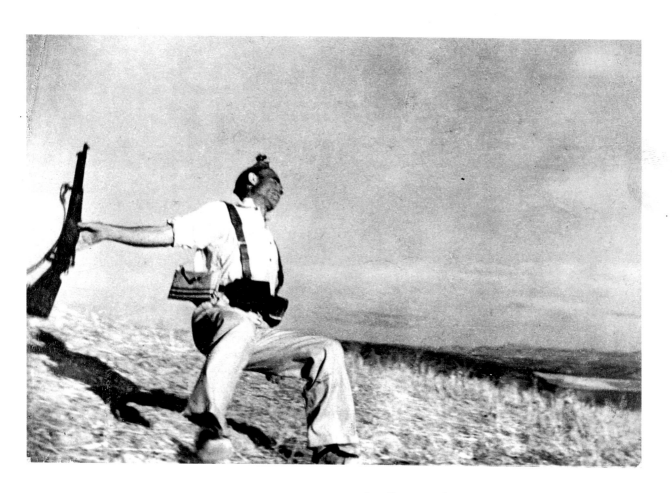

Robert Capa, Spain, *Espagne,* Spanien, 1936. **5**

6 | David Seymour, *France*, Frankreich, 24 May, *24 mai*, 24. Mai 1936.

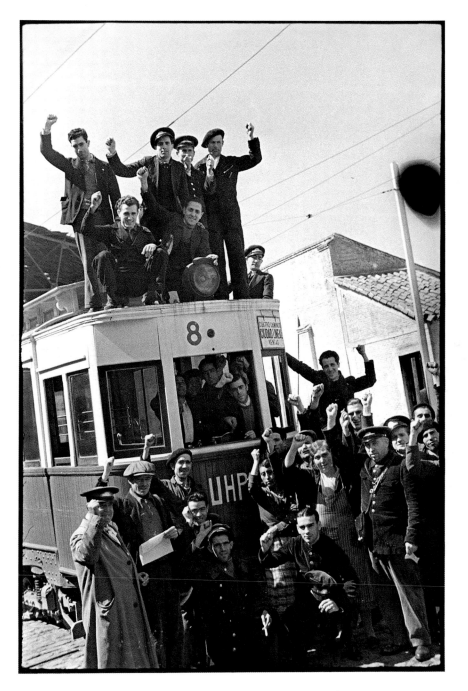

Robert Capa, Spain, *Espagne,* Spanien, 1935. **7**

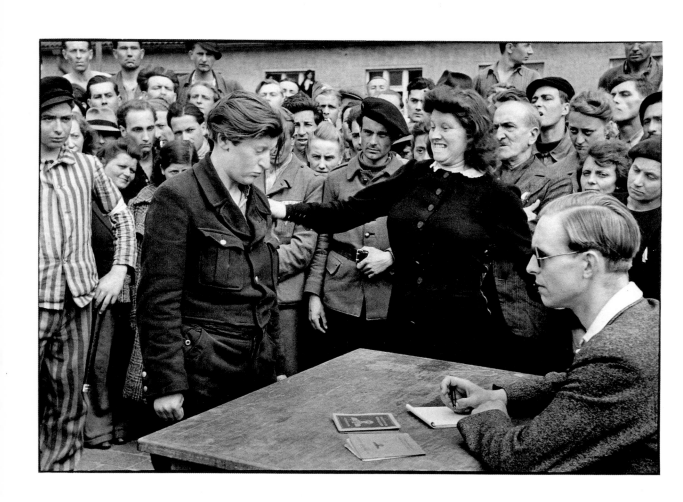

8 | Henri Cartier-Bresson, Germany, *Allemagne,* Deutschland, 1945.

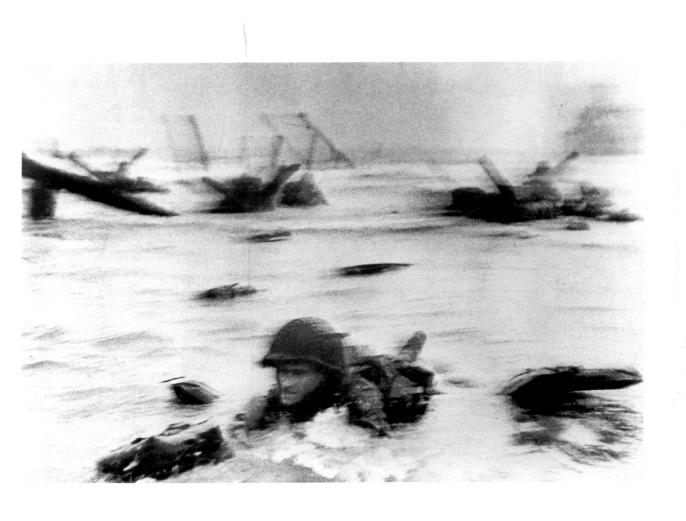

Robert Capa, *France,* Frankreich, 6 June, *6 juin,* 6. Juni 1944. **9**

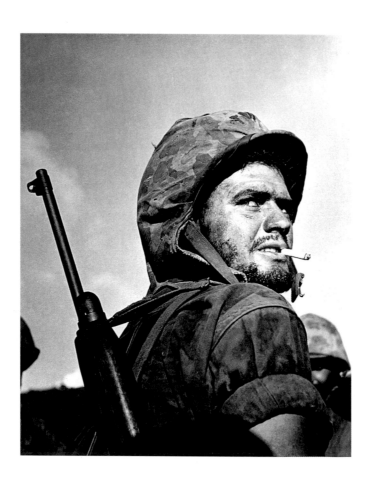

| W. Eugene Smith, the American Pacific campaign, *la guerre du Pacifique,* der amerikanische Pazific-Feldzug, 27 June, *27 juin,* 27. Juni 1944.

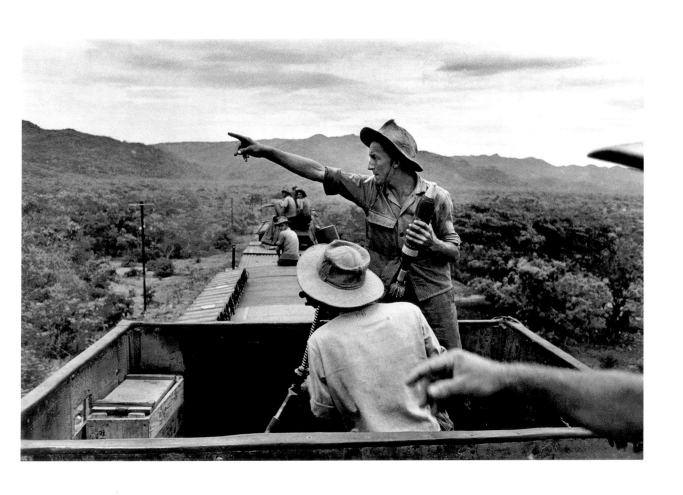

Werner Bischof, Indo-China, *Indochine,* Indochina 1952. **11**

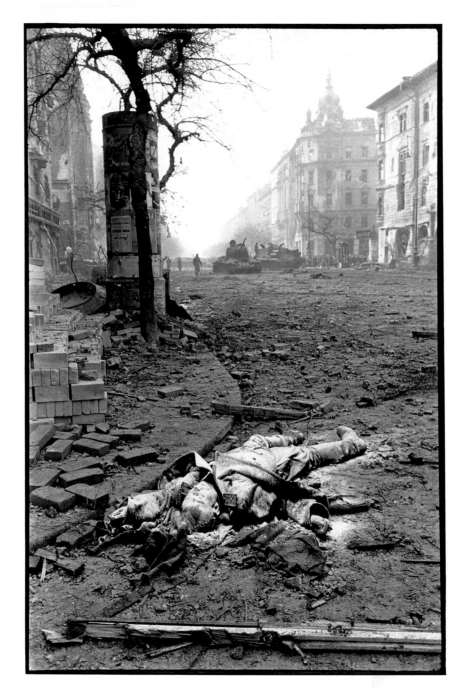

12 Erich Lessing, Hungary, *Hongrie,* Ungarn, October-November, *octobre-novembre,* Oktober-November 1956.

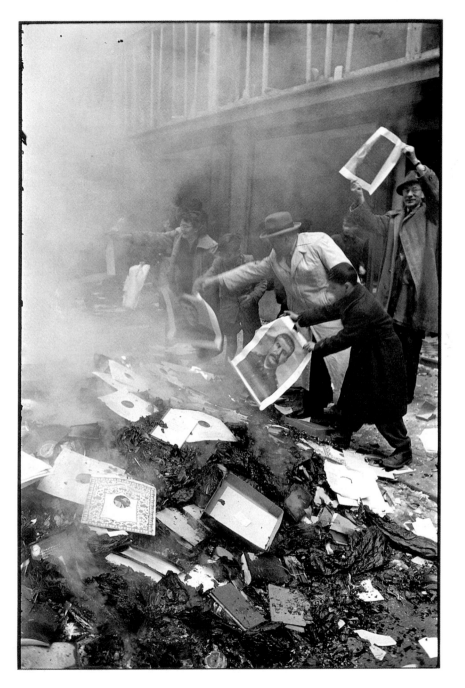

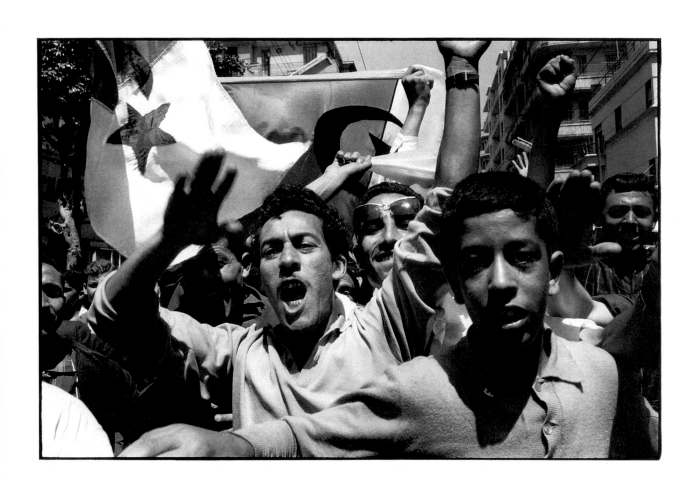

14 | Marc Riboud, Algeria, *Algérie,* Algerien, July, *juillet,* Juli 1962.

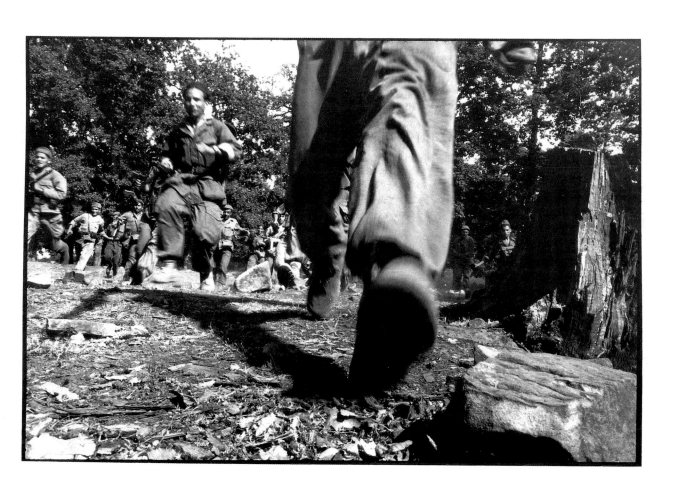

Kryn Taconis, Algeria, *Algérie,* Algerien, September, *septembre* 1957. **15**

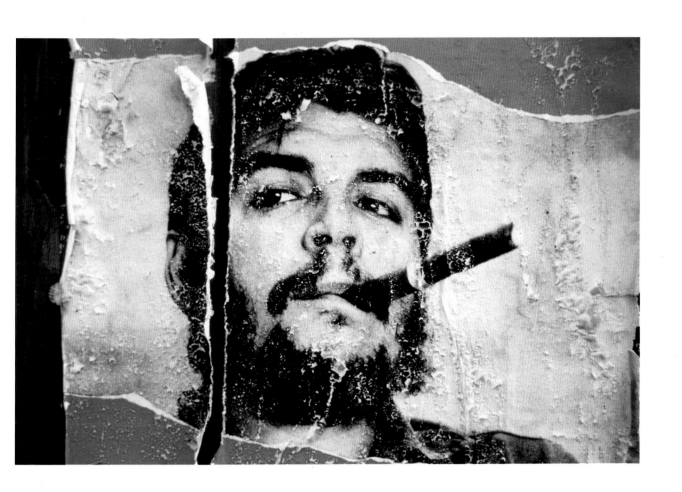

René Burri, Cuba/Switzerland, *Cuba/Suisse,* Kuba/Schweiz, 1963/1984. **17**

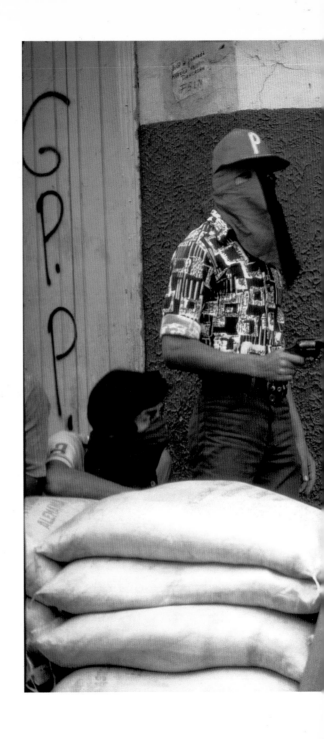

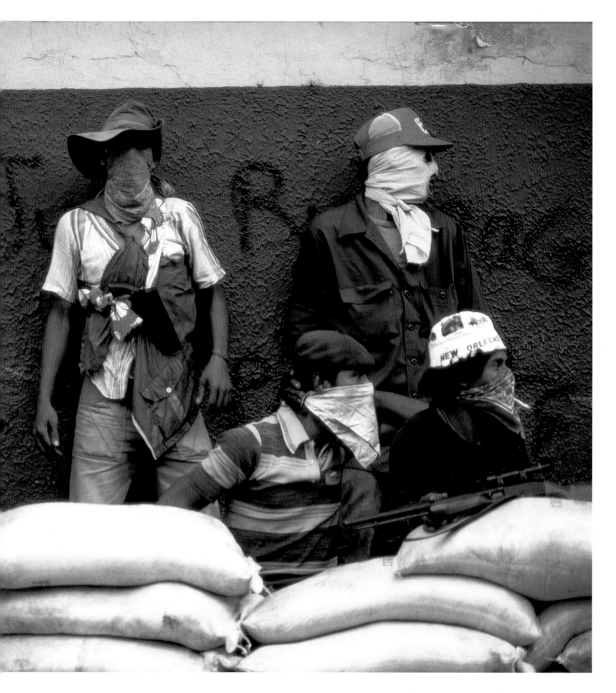

Susan Meiselas, *Nicaragua,* 1979. **19**

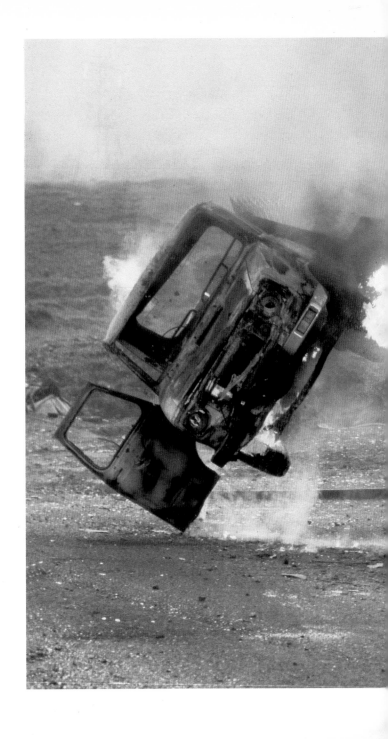

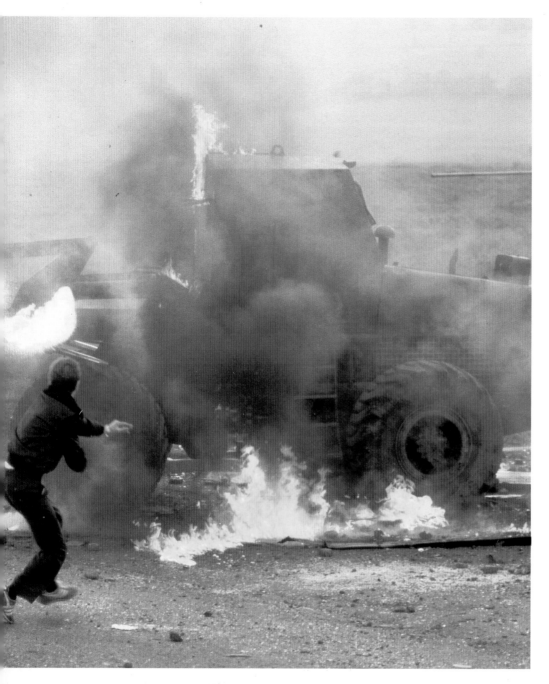

James Nachtwey, Northern Ireland, *Irlande du Nord,* Nordirland, 1981.

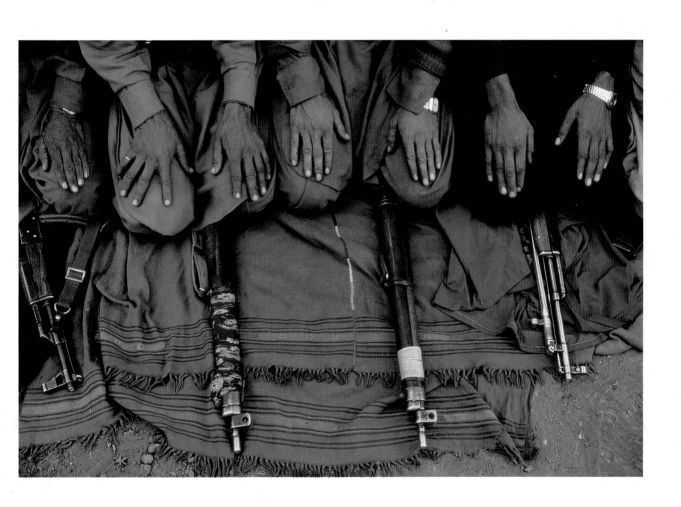

James Nachtwey, *Afghanistan*, 1986. **23**

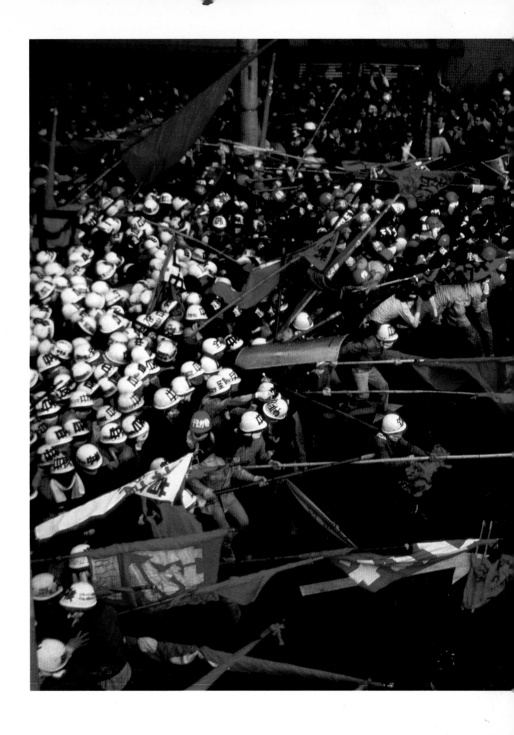

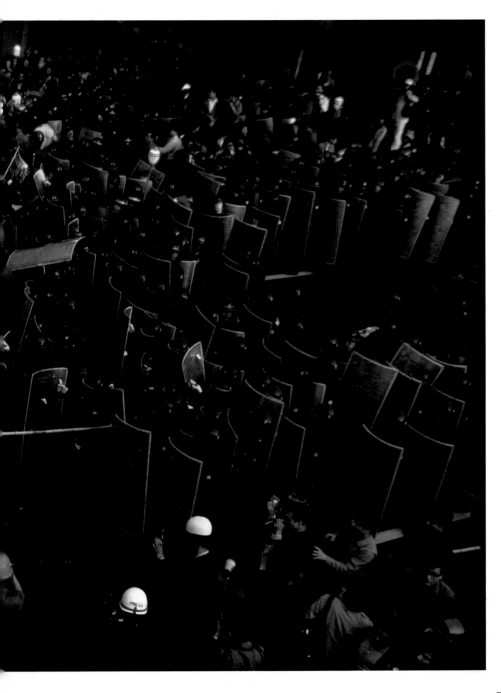

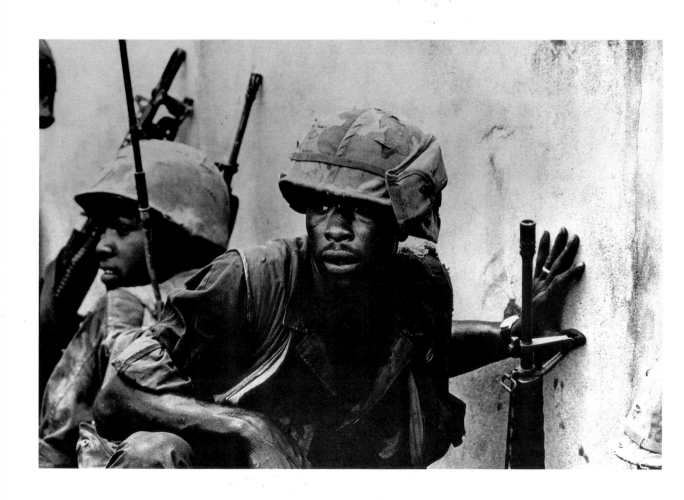

| Philip Jones Griffiths, South Vietnam, *Sud-Viêtnam,* Südvietnam, 1968.

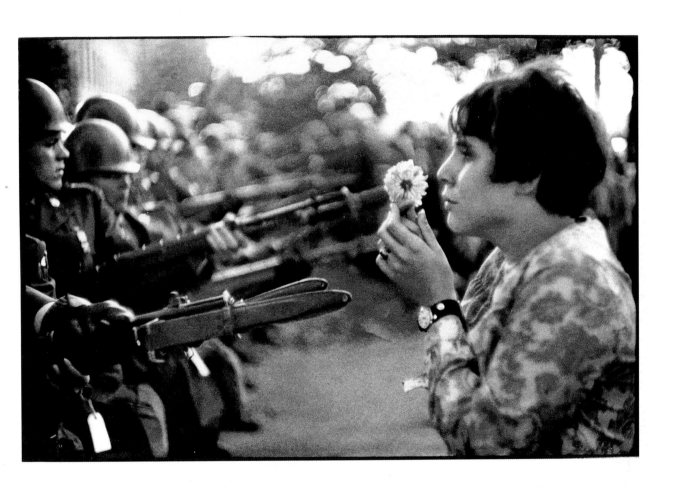

Marc Riboud, USA, *États-Unis,* 21 October, *21 octobre,* 21. Oktober 1967. **27**

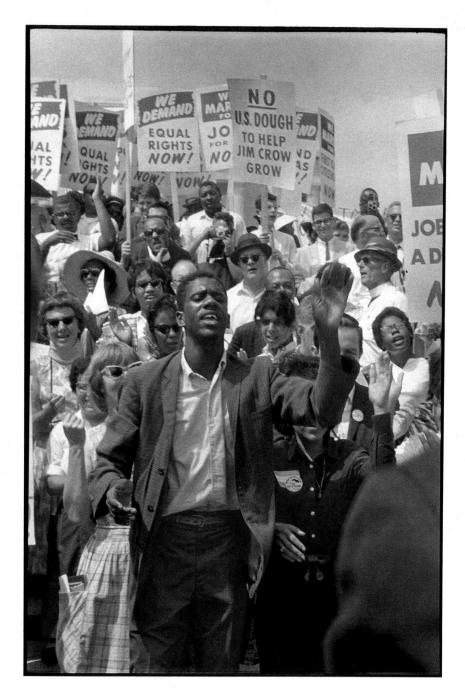

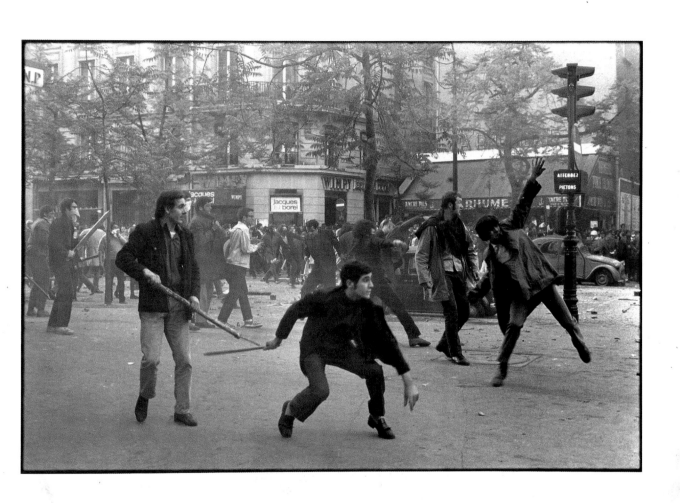

Bruno Barbey, *France*, Frankreich, May, *Mai* 1968. **29**

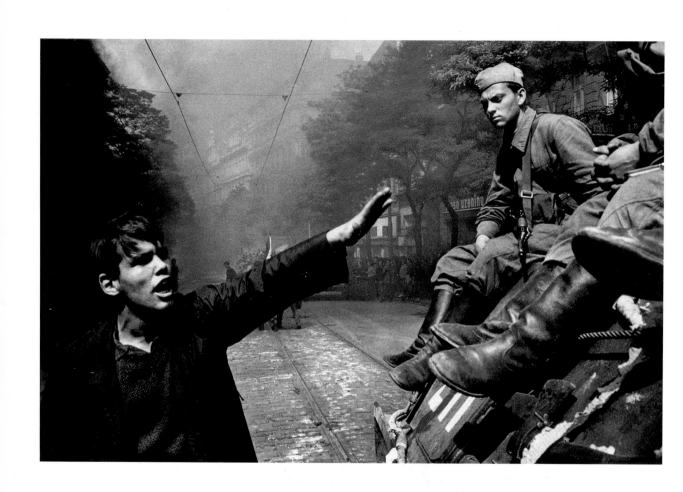

Josef Koudelka, Czechoslovakia, *Tchécoslovaquie,* Tschechoslowakei, August, *août* 1968.

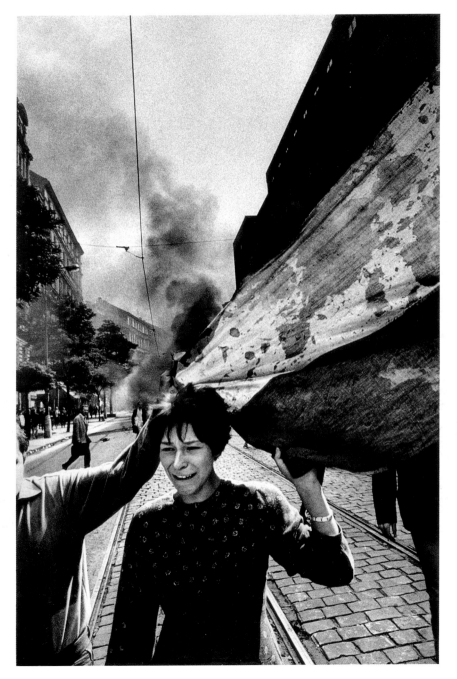

Josef Koudelka, Czechoslovakia, *Tchécoslovaquie,* Tschechoslowakei, August, *août* 1968. | **31**

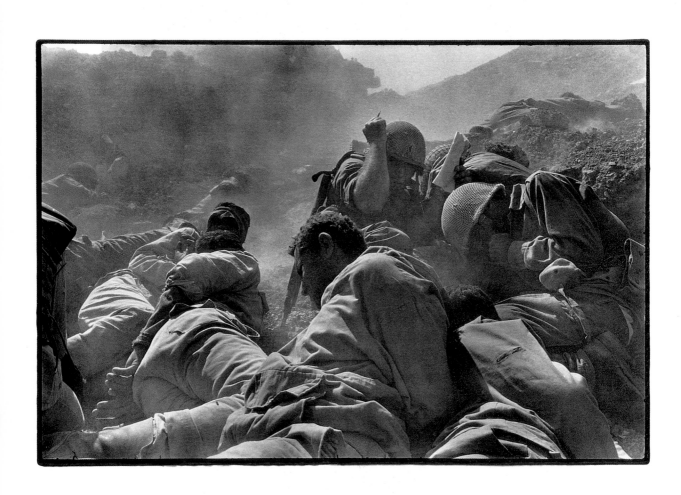

32 | Micha Bar-Am, Suez Canal, *canal de Suez,* Suezkanal, 1973.

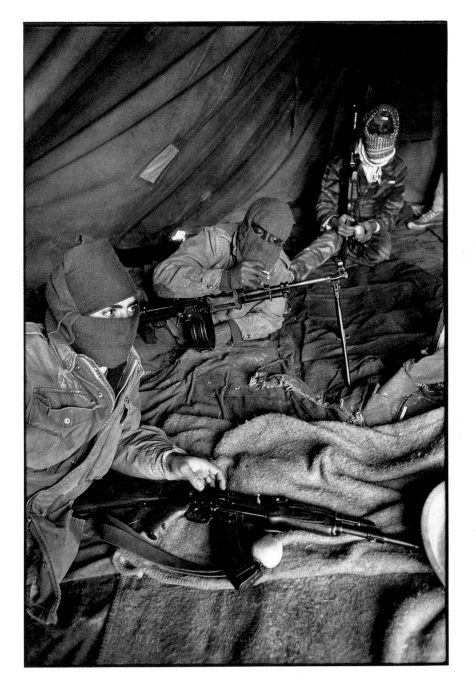

Bruno Barbey, Jordan, *Jordanie,* Jordanien, 1969.

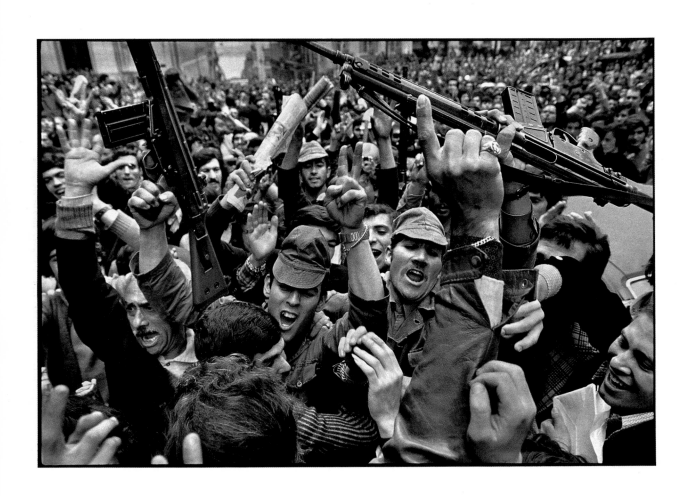

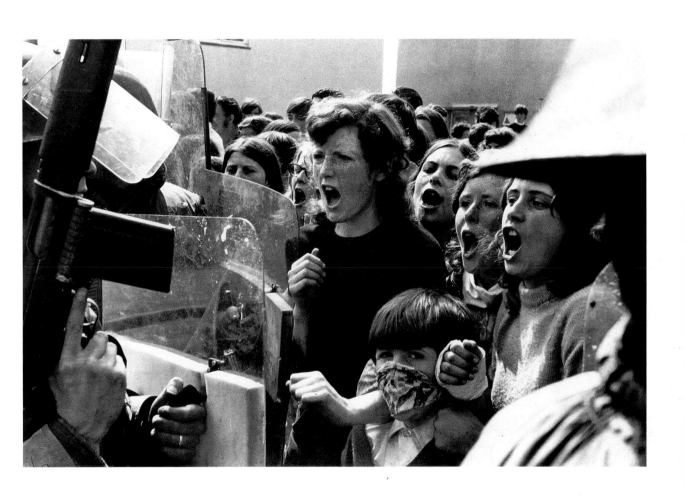

Leonard Freed, Northern Ireland, *Irlande du Nord,* Nordirland, 1971. | **35**

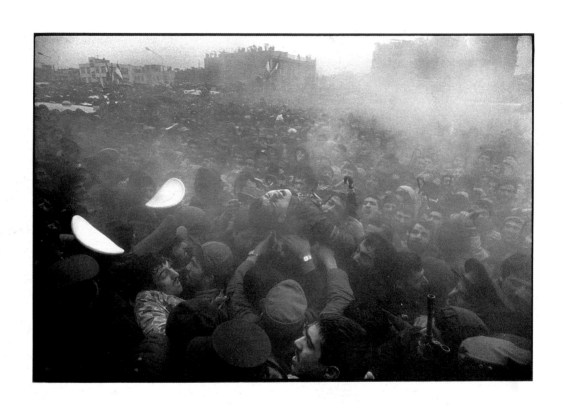

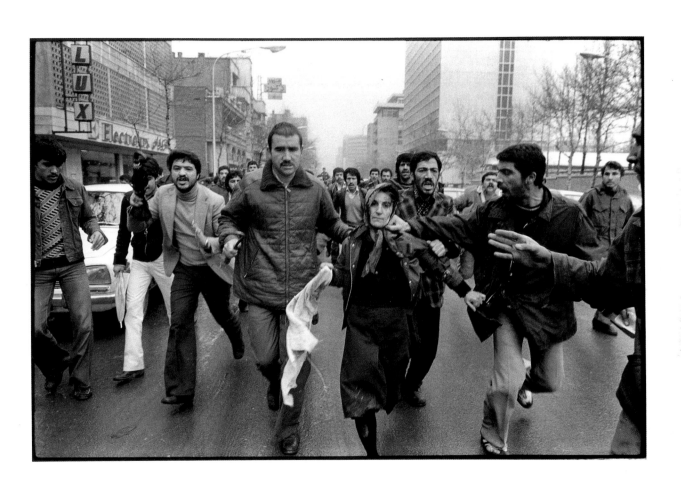

Abbas, *Iran,* 1979. **37**

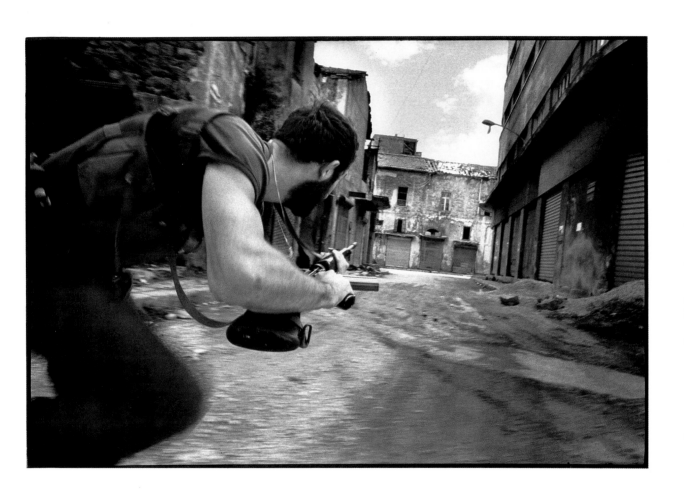

Raymond Depardon, Lebanon, *Liban,* Libanon, 1978. **39**

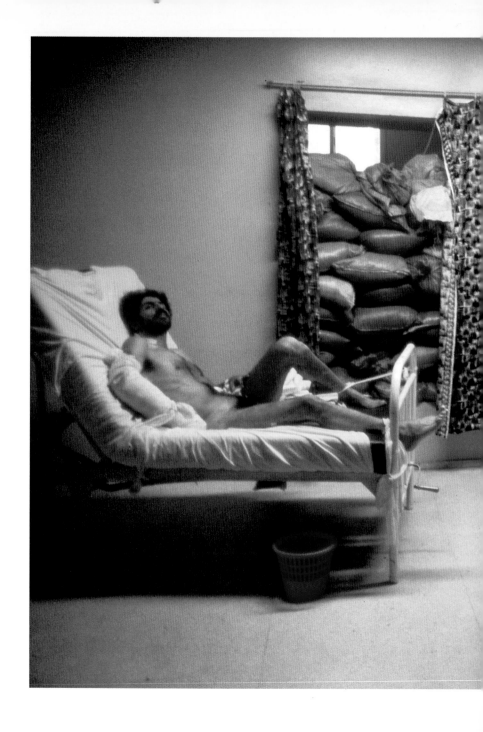

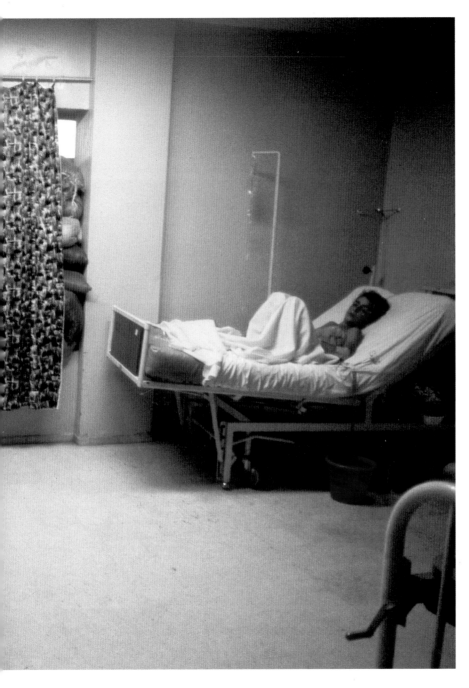

Alex Webb, Lebanon, *Liban,* Libanon, 1982.

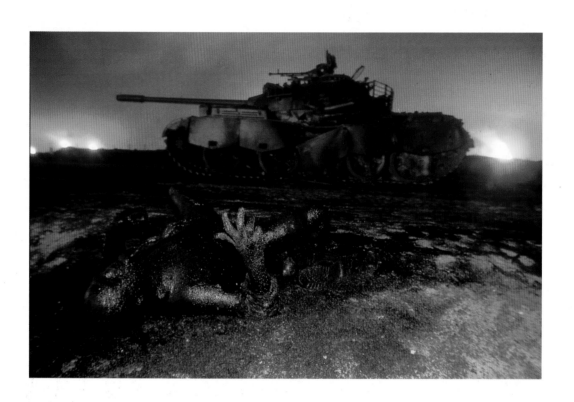

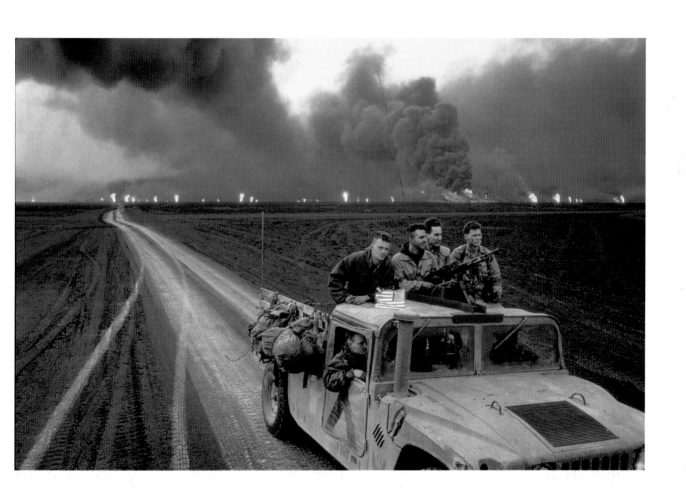

Bruno Barbey, Kuwait, *Koweit,* 1991. **43**

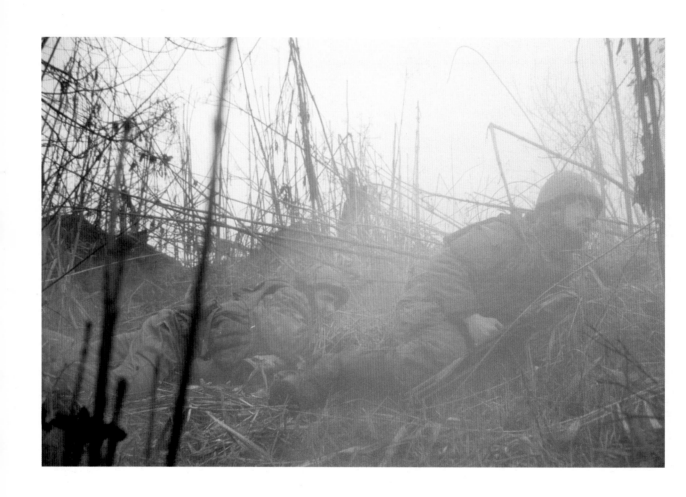

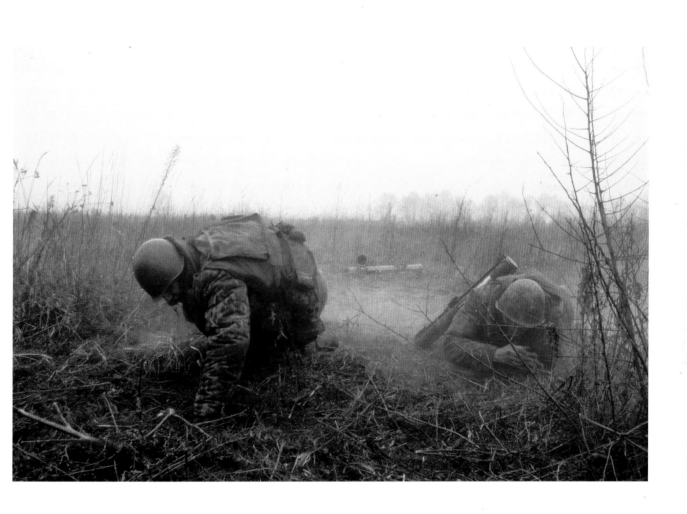

Luc Delahaye, CIS, Chechnya, *CEI, Tchétchénie,* Tschetschenien, ART, 1995. **45**

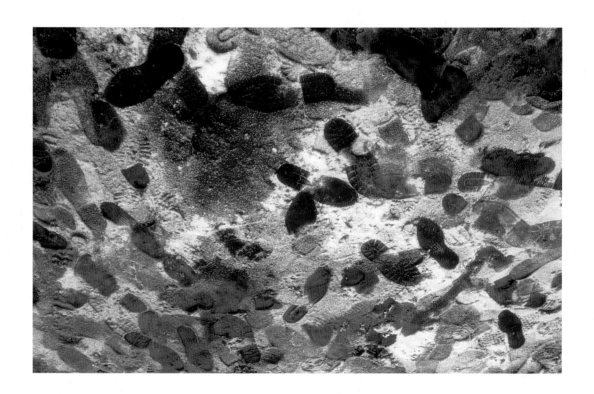

Paul Lowe, CIS, Chechnya, *CEI, Tchétchénie,* Tschetschenien, ART, 1994.

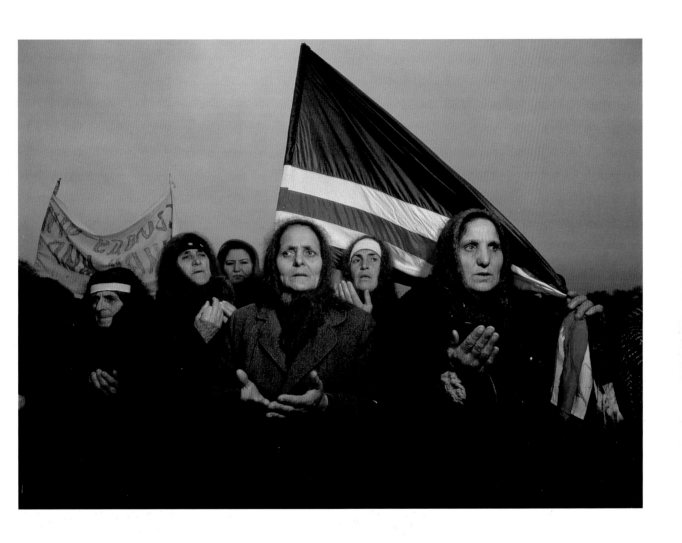

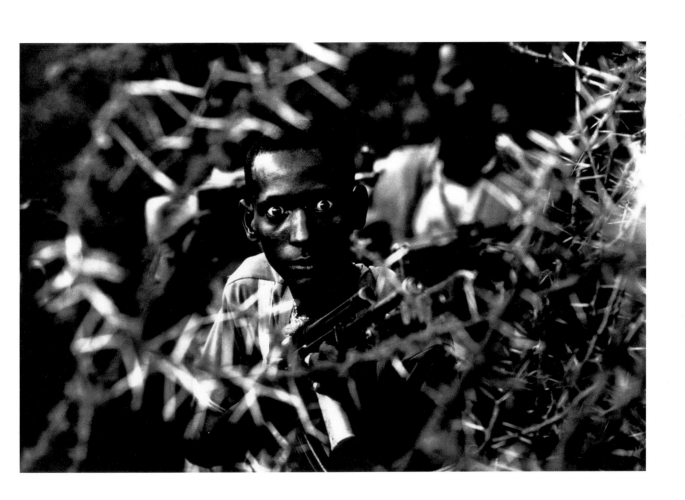

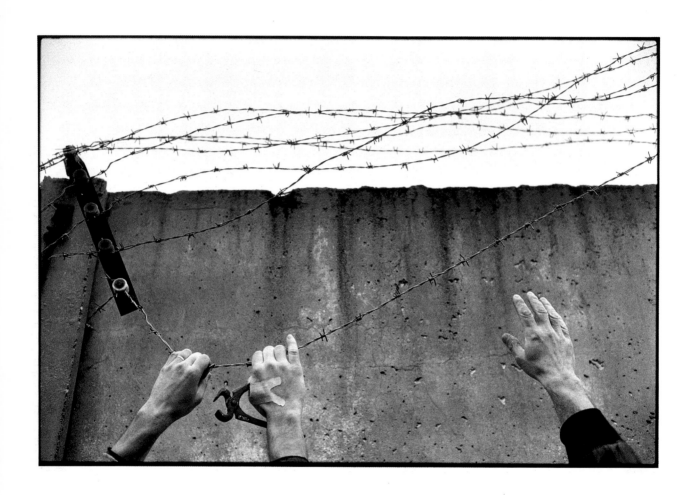

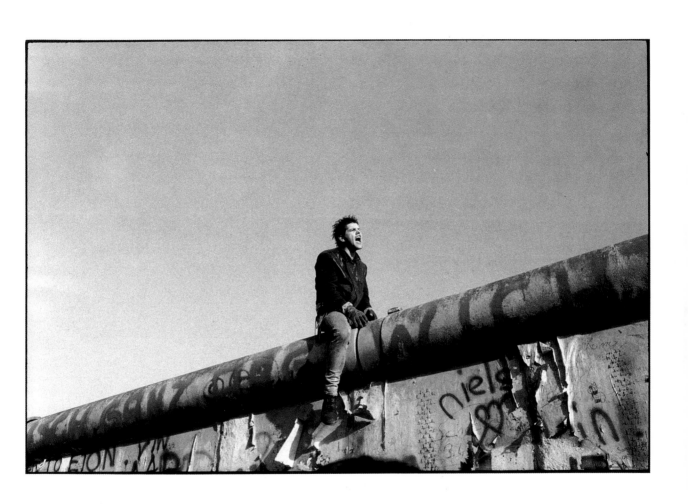

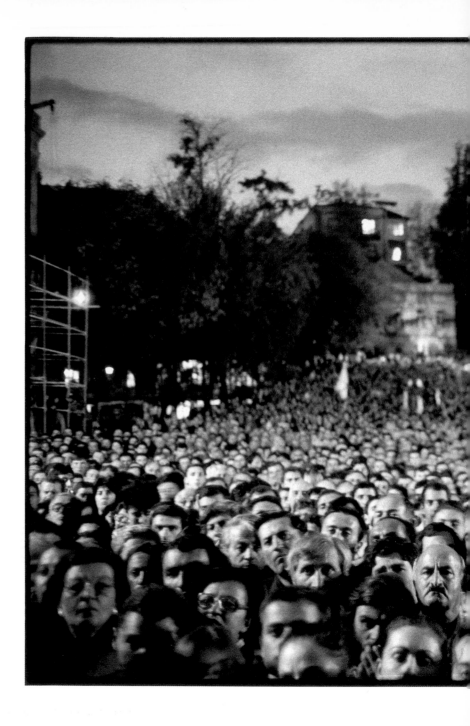

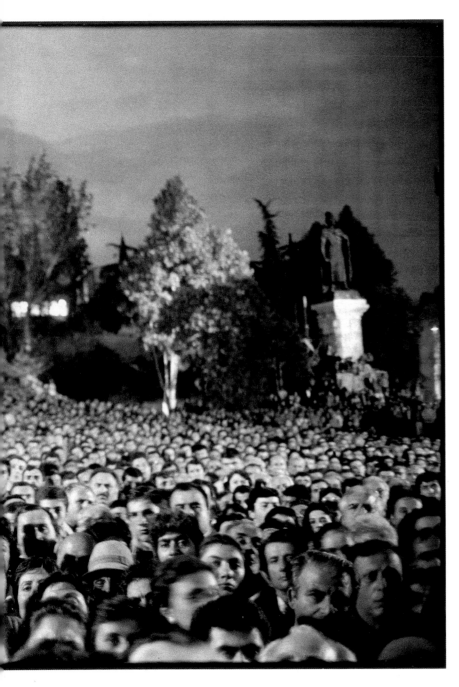

Patrick Zachmann, USSR, Georgia, *URSS, Géorgie,* UdSSR, Georgien, 1989. **53**

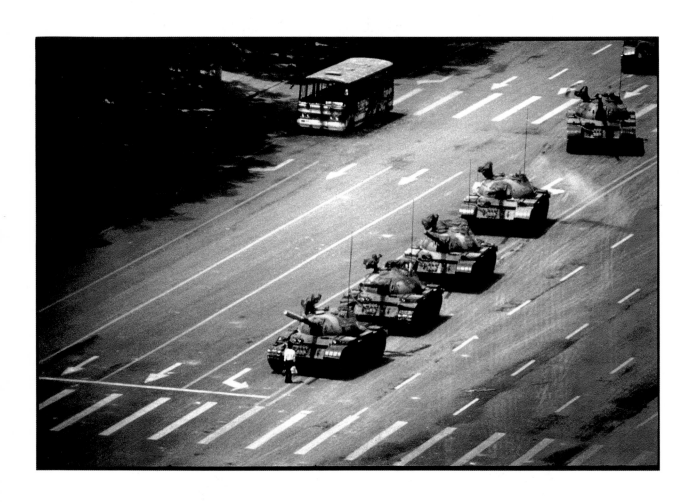

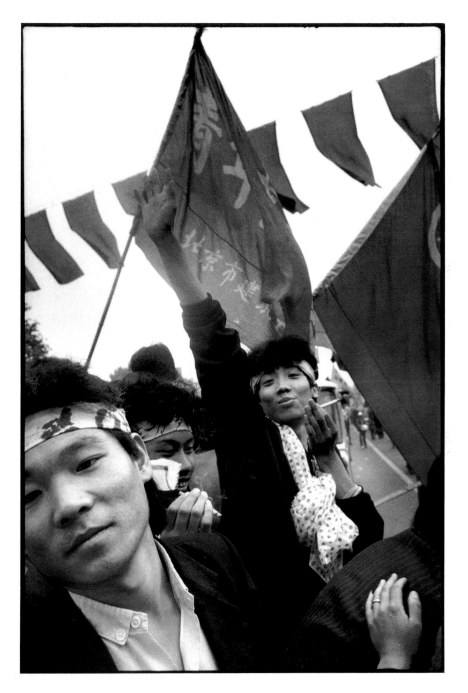

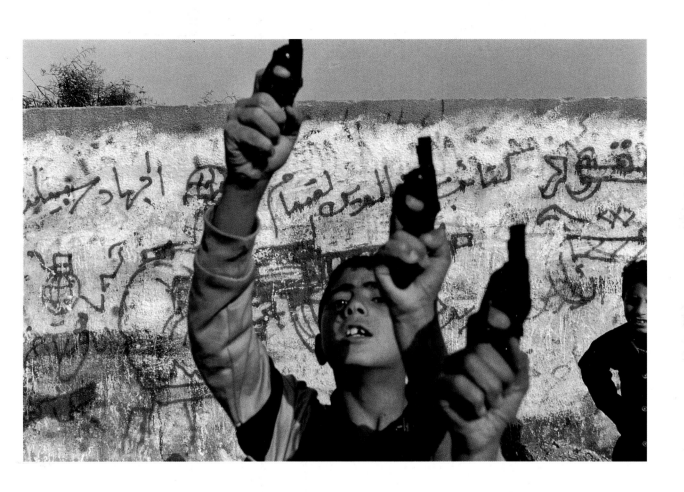

Larry Towell, Gaza Strip, *bande de Gaza,* Gazastreifen, 1993. | **57**

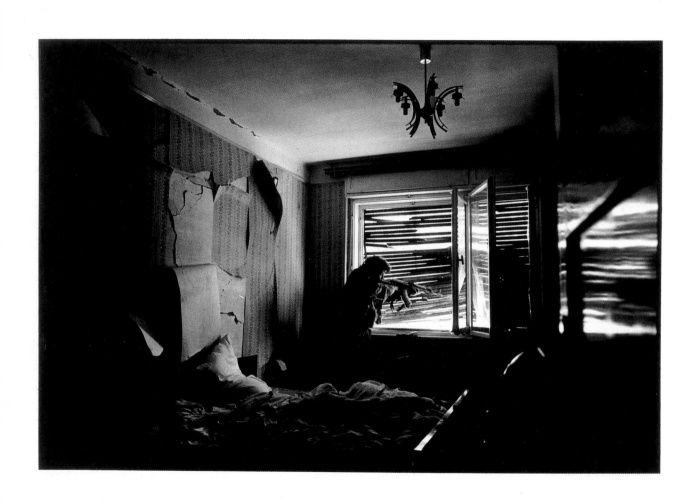

| James Nachtwey, Bosnia, *Bosnie,* Bosnien, May, *mai* 1993.

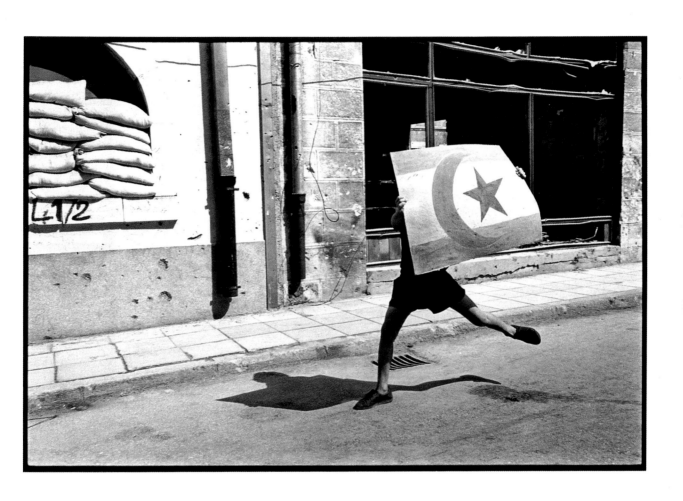

Gilles Peress, Bosnia, *Bosnie, Bosnien,* 1993. **59**

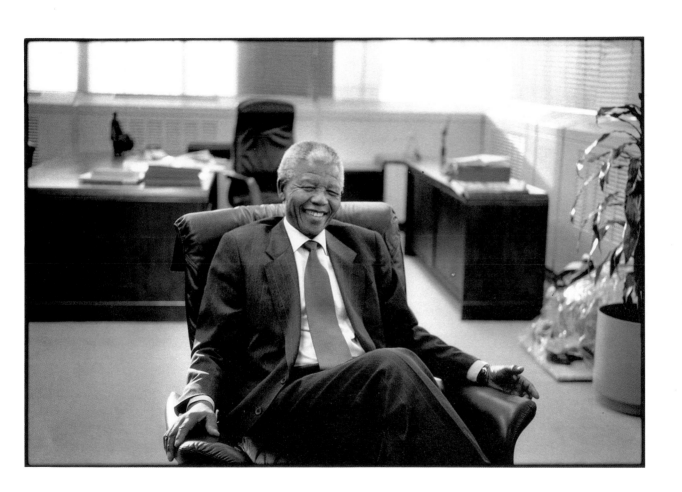

Raymond Depardon, South Africa, *Afrique du Sud,* Südafrika, 1993. **61**

Page 5: Death of a Republican soldier during the Spanish Civil War. Robert Capa, 1936.
Page 5 : Mort d'un soldat républicain pendant la guerre d'Espagne. Robert Capa, 1936.
Seite 5: Tod eines republikanischen Soldaten im spanischen Bürgerkrieg. Robert Capa, 1936.

Page 6: Homage to the dead of the Paris Commune; facing the Mur des Fédérés, members of the "Mars" chorale had climbed the small chapels in the Père Lachaise cemetery; left to right: Charles Dinerstein (later died in a concentrationcamp); Simon Lichtenstein; Solange Roche-Farger; Francis Lemarque, singer, author, composer; Henri Fush and Michel Roche-Farger. Paris, France. David Seymour, 24 May 1936.
Page 6 : Manifestation en hommage aux morts de la Commune de Paris ; face au mur des Fédérés, la chorale populaire « Mars » a escaladé les petites chapelles du cimetière du Père Lachaise ; de gauche à droite : Charles Dinerstein, mort en déportation ; Simon Lichtenstein ; Solange Roche-Farger ; Francis Lemarque, chanteur, auteur, compositeur ; Henri Fush et Michel Roche-Farger. Paris, France. David Seymour, 24 mai 1936.
Seite 6: Kundgebung zu Ehren der Toten der Pariser Kommune; gegenüber der Mauer der Verbündeten stieg der populäre Choral „Mars" auf die kleinen Kapellen des Friedhofs Père Lachaise. Von links nach rechts: Charles Dinerstein, umgekommen auf der Deportation; Simon Lichtenstein; Solange Roche-Farger; Francis Lemarque, Sänger, Autor, Komponist; Henri Fush und

Michel Roche-Farger. Paris, Frankreich. David Seymour, 24. Mai 1936.

Page 7: Union of proletarian brothers. Madrid, Spain. Robert Capa, 1935.
Page 7 : Union des frères prolétaires. Madrid, Espagne. Robert Capa, 1935.
Seite 7: Union der proletarischen Brüder. Madrid, Spanien. Robert Capa, 1935.

Page 8: A young Gestapo informer is exposed by one of her victims in a refugee camp. Dessau, Germany. Henri Cartier-Bresson, 1945.
Page 8 : Une jeune indicatrice de la Gestapo est démasquée par une de ses victimes dans un camp de transit pour réfugiés. Dessau, Allemagne. Henri Cartier-Bresson, 1945.
Seite 8: Eine junge, von ihrem Opfer in einem Durchgangslager als Gestapo-Spitzel erkannte Frau. Dessau, Deutschland. Henri Cartier-Bresson, 1945.

Page 9: Landing of the first wave of American troops at Omaha Beach, near Colleville-sur-Mer. Normandy, France. Robert Capa, 6 June 1944.
Page 9 : Débarquement de la première vague de troupes américaines à Omaha Plage, près de Colleville-sur-Mer. Normandie, France. Robert Capa, 6 juin 1944.
Seite 9: Landung der ersten Welle amerikanischer Truppen in Omaha Beach bei Colleville-sur-Mer. Normandie, Frankreich. Robert Capa, 6. Juni 1944.

Page 10: A US marine after the attack on Saipan during the American Pacific campaign during World War II. W. Eugene Smith, 27 June 1944.
Page 10 : Marine américain

après l'attaque sur l'île de Saipan lors de la campagne des Américains dans le Pacifique pendant la Seconde Guerre mondiale.
W. Eugene Smith, 27 juin 1944.
Seite 10: Amerikanischer Marine nach dem Angriff auf die Insel Saipan während des amerikanischen Pazifik-Feldzugs im Zweiten Weltkrieg. W. Eugene Smith, 27. Juni 1944.

Page 11: The "Rafale", an armoured train ensuring the regular journey between Saigon and Nha Trang. Indo-China. Werner Bischof, 1952.
Page 11 : Le « Rafale », train blindé et protégé assurant le trajet régulier entre Saïgon et Nha Trang. Indochine. Werner Bischof, 1952.
Seite 11: Der gepanzerte, regelmäßig zwischen Saigon und Nha Trang verkehrende Zug „Rafale". Indochina. Werner Bischof, 1952.

Page 12: Corpse of a Soviet officer with destroyed tanks in the background, after fierce street battles during the Budapest uprising, Hungary, October-November 1956. Erich Lessing, 1956.
Page 12 : Cadavre d'un officier soviétique et chars détruits en arrière-plan, après des combats de rue féroces lors de l'insurrection de Budapest, Hongrie, en octobre-novembre 1956. Erich Lessing, 1956.
Seite 12: Die Leiche eines sowjetischen Offiziers und im Hintergrund zerstörte Panzer nach heftigen Straßenkämpfen während des Budapester Aufstandes. Ungarn, Oktober/November 1956. Erich Lessing, 1956.

Page 13: Auto-da-fé of Soviet propaganda material (books and

portraits of Stalin) during the Budapest uprising. Hungary. Erich Lessing, October-November 1956.
Page 13 : Autodafé de matériel de propagande soviétique (livres et portraits de Staline), lors de l'insurrection de Budapest. Hongrie. Erich Lessing, octobre-novembre 1956.
Seite 13: Verbrennung von sowjetischem Propagandamaterial (Bücher und Stalinporträts) während des Budapester Aufstandes. Ungarn. Erich Lessing, Oktober/November 1956.

Page 14: Crowds in the streets of Algiers during the festivities following Algerian independence. Marc Riboud, July 1962.
Page 14 : La foule dans les rues d'Alger pendant les fêtes qui suivirent l'indépendance de l'Algérie. Marc Riboud, juillet 1962.
Seite 14: Die Unabhängigkeit feiernde Menschenmenge in den Straßen von Algier. Marc Riboud, Juli 1962.

Page 15: FLN soldiers running to shelter after having sighted a French reconnaissance aircraft, Algeria. Kryn Taconis, September 1957.
Page 15 : Soldats du FLN courant s'abriter après avoir aperçu un avion de reconnaissance français. Algérie. Kryn Taconis, septembre 1957.
Seite 15: Vor einem französischen Aufklärungsflugzeug schutzsuchende Soldaten der Befreiungsfront. Algerien. Kryn Taconis, September 1957.

Page 17: Poster of "Che" for the 25th anniversary of the Cuban revolution, after a picture by René Burri. Cuba/Zurich. René Burri, 1963/1984.

Page 17 : *Affiche du « Che » pour le 25ᵉ anniversaire de la révolution cubaine, d'après une image de René Burri. Cuba/Zurich. René Burri, 1963/1984.*
Seite 17: Che-Plakat nach einem Foto von René Burri für die 25. Jahresfeier der kubanischen Revolution. Kuba/Zürich. René Burri, 1963/1984.

Page 18-19 : Combatants before the guards' counter-attack at Matagalpa. Nicaragua. Susan Meiselas, 1979.
Page 18-19 : *Combattants avant la contre-attaque de la garde à Matagalpa. Nicaragua. Susan Meiselas, 1979.*
Seite 18-19: Kämpfer vor dem Gegenangriff der Garde in Matagalpa. Nicaragua. Susan Meiselas, 1979.

Page 20-21: Catholics throw petrol bombs at British armoured car, Belfast, Northern Ireland. James Nachtwey, 1981.
Page 20-21 : *Des catholiques jettent des cocktails Molotov contre un véhicule blindé de l'armée britannique. Belfast, Irlande du Nord. James Nachtwey, 1981.*
Seite 20-21: Katholiken bewerfen ein gepanzertes Fahrzeug der britischen Armee mit Molotow-Cocktails. Belfast, Nordirland. James Nachtwey, 1981.

Page 23: Combatants at prayer. Kunar Valley, Afghanistan. James Nachtwey, 1986.
Page 23 : *Combattants en prière. Vallée Kunar, Afghanistan. James Nachtwey, 1986.*
Seite 23: Kämpfer beim Gebet. Kunar-Tal, Afghanistan. James Nachtwey, 1986.

Page 24-25: Demonstration at Narita airport. Tokyo, Japan. Bruno Barbey, 1971.
Page 22-25 : *Manifestation à l'aéroport de Narita. Tokyo,*

Japon. Bruno Barbey, 1971.
Seite 24-25: Demonstration am Flugplatz Narita. Tokyo, Japan. Bruno Barbey, 1971.

Page 26: The Tet Offensive during the battle for Saigon. South Vietnam. Philip Jones Griffiths, 1968.
Page 26 : *Offensive du Têt pendant la bataille de Saïgon. Sud-Viêtnam. Philip Jones Griffiths, 1968.*
Seite 26: Têt-Offensive während der Schlacht von Saigon. Südvietnam. Philip Jones Griffiths, 1968.

Page 27: Anti-Vietnam War demonstration. Washington, USA. Marc Riboud, 21 October 1967.
Page 27 : *Manifestation contre la guerre du Viêtnam. Washington, États-Unis. Marc Riboud, 21 octobre 1967.*
Seite 27: Anti-Vietnamkriegs-Demonstration. Washington, USA. Marc Riboud, 21. Oktober 1967.

Page 28: The Selma March, a demonstration for the civil rights of black American citizens. Washington, USA. Leonard Freed, 1963.
Page 28 : *Marche de Selma, manifestation pour les droits civiques des citoyens noirs américains. Washington, États-Unis. Leonard Freed, 1963.*
Seite 28: Selma-Marsch. Demonstration für die Bürgerrechte schwarzer amerikanischer Bürger. Washington, USA. Leonard Freed, 1963.

Page 29: The Latin Quarter during the events of May 1968. Paris, France. Bruno Barbey, 1968.
Page 29 : *Quartier latin lors des événements de Mai 1968. Paris, France. Bruno Barbey, 1968.*
Seite 29: Quartier Latin im

Mai' 68. Paris, Frankreich. Bruno Barbey, 1968.

Page 30: Warsaw Pact troops in front of the radio headquarters during the invasion of Prague. Czechoslovakia. Josef Koudelka, August 1968.
Page 30 : *Troupes du Pacte de Varsovie devant la maison de la Radio lors de l'invasion de Prague. Tchécoslovaquie, Josef Koudelka, août 1968.*
Seite 30: Truppen des Warschauer Paktes vor dem Funkhaus beim Einfall in Prag. Prag, Tschechoslowakei. Josef Koudelka, August 1968.

Page 31: Invasion of Prague by the Warsaw Pact troops. Czechoslovakia. Josef Koudelka, August 1968.
Page 31 : *Invasion de Prague par les troupes du Pacte de Varsovie. Tchécoslovaquie, Josef Koudelka, août 1968.*
Seite 31: Invasion der Truppen des Warschauer Paktes in Prag. Tschechoslowakei. Josef Koudelka, August 1968.

Page 32: The Yom Kippur War, artillery barrage. The Suez Canal. Micha Bar-Am, 1973.
Page 32 : *Guerre du Kippour, barrage d'artillerie. Canal de Suez. Micha Bar-Am, 1973.*
Seite 32: Yom-Kippur-Krieg, Artilleriesperre. Suezkanal. Micha Bar-Am, 1973.

Page 33: Palestinian Al Fatah training camp, with masked members of the guerrilla movement. Jordan. Bruno Barbey, 1969.
Page 33 : *Camp d'entraînement palestinien Al-Fatah, avec des membres masqués du mouvement de guérilla. Jordanie. Bruno Barbey, 1969.*
Seite 33: Palästinensisches Al-Fatah-Übungslager mit vermummten Mitgliedern der Guerilla-Bewegung. Jordanien. Bruno Barbey, 1969.

Page 34: The people hail their liberators. The Carnation Revolution, Lisbon, Portugal. Gilles Peress, 25 April 1974.
Page 34 : *Le peuple acclame ses libérateurs. Révolution des Œillets, Lisbonne, Portugal. Gilles Peress, 25 avril 1974.*
Seite 34: Das Volk jubelt seinen Befreiern zu. Revolution der Nelken, Lissabon, Portugal. Gilles Peress, 25. April 1974.

Page 35: Catholic women demonstrate against British troops. Northern Ireland. Leonard Freed, 1971.
Page 35 : *Manifestation de femmes catholiques contre les troupes britanniques. Irlande du Nord. Leonard Freed, 1971.*
Seite 35: Demonstration katholischer Frauen gegen die britischen Truppen. Nordirland. Leonard Freed, 1971.

Page 36: A man faints during the first anniversary of the Revolution on February the 11th 1980. Iran. Abbas, 1980.
Page 36 : *Évanouissement d'un homme lors de la commémoration de la révolution le 11 février 1980. Iran. Abbas, 1980.*
Seite 36: Ohnmachtsanfall eines Mannes bei der Feier der Revolution vom 11. Februar 1980. Abbas, 1980.

Page 37: A woman suspected of supporting the Shah, lynched by the revolutionary crowd. Tehran, Iran. Abbas, 1979.
Page 37 : *Une femme soupçonnée d'être partisane du Shah, lynchée par la foule des révolutionnaires. Téhéran, Iran. Abbas, 1979.*
Seite 37: Eine als Anhängerin des Schahs verdächtigte Frau wird von Revolutionären

gelyncht. Teheran, Iran.
Abbas, 1979.

Page 39: Beirut, Lebanon.
Raymond Depardon, 1978.
Page 39 : *Beyrouth, Liban.*
Raymond Depardon, 1978.
Seite 39: Beirut, Libanon.
Raymond Depardon, 1978.

Page 40-41: Hospital in West
Beirut, Lebanon.
Alex Webb, 1982.
Page 40-41 : *Hôpital à*
Beyrouth-Ouest, Liban.
Alex Webb, 1982.
Seite 40-41: Krankenhaus
in Beirut-West, Libanon.
Alex Webb, 1982.

Page 42: A bitter scene of the
warfields. Kuwait.
Abbas, 1992.
Page 42 : *Les champs de*
bataille. Koweit.
Abbas, 1992.
Seite 42: Schlachtfelder.
Kuwait. Abbas, 1992.

Page 43: US marines
in the Burgan oilfield during
the Gulf War. Kuwait.
Bruno Barbey, 1991.
Page 43 : *Marines américains*
sur le gisement pétrolier de
Burgan pendant la guerre du
Golfe. Koweit.
Bruno Barbey, 1991.
Seite 43: Amerikanische
Marines an der Erdöllagerstätte
Burgan; Golfkrieg. Kuwait.
Bruno Barbey, 1991.

Pages 44 & 45: A battalion
of two hundred men on the front
line about three kilometres
(just under two miles) from
Argun. Chechnya, CIS.
Luc Delahaye, 1995.
Page 44 & 45 : *Un bataillon de*
deux cents hommes sur le front
à trois kilomètres environ
d'Argun. Tchétchénie, CEI.
Luc Delahaye, 1995.
Seite 44 & 45: Ein 200 Mann
starkes Bataillon an der Front
ca. drei Kilometer von Argun
entfernt. Tschetschenien, ART.

Luc Delahaye, 1995.

Page 46: Russians bomb
Grozny. Chechnya.
Paul Lowe, 1994.
Page 46 : *Les Russes*
bombardent Grozny.
Tchétchénie.
Paul Lowe, 1994.
Seite 46: Die Russen bombar-
dieren Grozny. Tschetschenien,
ART.
Paul Lowe, 1994.

Page 47: Chechnya, CIS.
Paul Lowe, 16 December 1994.
Page 47 : *Tchétchénie, CEI.*
Paul Lowe, 16 décembre 1994.
Seite 47: Tschetschenien, ART.
Paul Lowe, 16. Dezember 1994.

Page 49: A Western Somalian
Liberation Front guerrilla;
to compensate the lack of food,
the soldier has consumed
a large quantity of "qat", a leaf
containing a drug similar
to amphetamines. Somalia.
Philip Jones Griffiths, 1980.
Page 49 : *Soldat de la guérilla*
du Front de libération de la
Somalie occidentale ;
pour compenser la pénurie
de nourriture, le soldat a
consommé une grande quantitié
de « chat », une feuille
contenant une drogue similaire
aux amphétamines. Somalie.
Philip Jones Griffiths, 1980.
Seite 49: Guerilla-Soldat der
Befreiungsfront Westsomalias.
Um die mangelnde Nahrung zu
kompensieren, nahm der
Soldat eine große Menge
„Qat" zu sich: ein Blatt, das
eine mit Amphetaminen
vergleichbare Droge enthält.
Somalia.
Philip Jones Griffiths, 1980.

Page 50: Fall of the Berlin
Wall. Germany.
James Nachtwey, 1989.
Page 50 : *Chute du mur de*
Berlin. Allemagne.
James Nachtwey, 1989.
Seite 50: Fall der Berliner

Mauer. Deutschland.
James Nachtwey, 1989.

Page 51: Fall of the Berlin
Wall. Germany. Raymond
Depardon, November 1989.
Page 51 : *Chute du mur de*
Berlin. Allemagne. Raymond
Depardon, novembre 1989.
Seite 51: Fall der Berliner
Mauer. Deutschland. Raymond
Depardon, November 1989.

Page 52-53: Demonstration
in favour of independence in
Tbilisi. Georgia, USSR.
Patrick Zachmann, 1989.
Page 52-53 : *Manifestation*
indépendantiste à Tbilissi.
Géorgie, URSS.
Patrick Zachmann, 1989.
Seite 52-53: Demonstration
der Unabhängigkeitsbewegung
in Tiflis. Georgien, UdSSR.
Patrick Zachmann, 1989.

Page 54: The student rebellion,
Tienanmen Square. Beijing, China.
Stuart Franklin, 5 June 1989.
Page 54 : *Le « Printemps de*
Pékin », révolte des étudiants
place Tien an Men. Pékin, Chine.
Stuart Franklin, 5 juin 1989.
Seite 54: Studentenrevolte
auf dem Platz des Himmlischen
Friedens. Peking, China.
Stuart Franklin, 5. Juni 1989.

Page 55: Beijing, China. Patrick
Zachmann, 18 May 1989.
Page 55 : *Pékin, Chine. Patrick*
Zachmann, 18 mai 1989.
Seite 55: Peking, China.
Patrick Zachmann, 18. Mai
1989.

Page 56: Damascus Gate,
the entrance to the walled city
and the Arab quarter of East
Jerusalem. Israel.
Larry Towell, 1994.
Page 56 : *La porte de Damas,*
entrée de la vieille ville et du
quartier arabe de Jérusalem-Est.
Israël, Larry Towell, 1994.
Seite 66: Das Tor von
Damaskus, Zugang zur Altstadt

und zum arabischen Viertel von
Ostjerusalem. Israel.
Larry Towell, 1994.

Page 57: Children playing in
the Gaza Strip.
Larry Towell, 1993.
Page 57 : *Jeux d'enfants dans*
la bande de Gaza.
Larry Towell, 1993.
Seite 57: Kinderspiele im
Ghazastreifen.
Larry Towell, 1993.

Page 58: Fighting between
Croat and Muslim forces.
Mostar, Bosnia.
James Nachtwey, May 1993.
Page 58 : *Combat entre les*
forces croates et musulmanes.
Mostar, Bosnie.
James Nachtwey, mai 1993.
Seite 58: Kampf zwischen
Kroaten und Moslems.
Mostar, Bosnien.
James Nachtwey, Mai 1993.

Page 59: Sniper fire, Mostar,
Bosnia. Gilles Peress, 1993.
Page 59 : *Tir de snipers,*
Mostar, Bosnie. Gilles Peress,
1993.
Seite 59: Sniper-Beschuß,
Mostar, Bosnien. Gilles Peress,
1993.

Page 61: Nelson Mandela,
leader of the ANC, in his office in
Johannesburg. South Africa.
Raymond Depardon, 1993.
Page 61 : *Nelson Mandela,*
leader de l'ANC, dans son bureau
à Johannesbourg. Afrique du
Sud. Raymond Depardon, 1993.
Seite 61: Nelson Mandela,
Präsident des ANC, in seinem
Johannesbuger Büro.
Südafrika.
Raymond Depardon, 1993.